PASSIVE
AGGRESSIVE
NOTES

PASSIVE AGGRESSIVE* NOTES

PAINFULLY POLITE AND HILARIOUSLY HOSTILE WRITINGS

Kerry Miller

*and just plain aggressive

COLLINS

An Imprint of HarperCollinsPublishers

HarperCollins books may be purchased for educational, business, or sales promotional use. For information, please write: Special Markets Department, HarperCollins Publishers, 10 East 53rd Street, New York, NY 10022.

FIRST EDITION

Designed by Renato Stanisic

Library of Congress Cataloging-in-Publication Data has been applied for.

ISBN 978-0-06-163059-0

08 09 10 11 12 ID/RRD 10 9 8 7 6 5 4 3 2 1

For all of the roommates, suitemates, housemates and flatmates who've put up with me over the years...

Brooks, Kim, Juliette, Larissa
Pam, Alex, Dave, Austin, Eric
Jessica, Sara, Josh, Dan, SarahP.
Joe, Tim, Joe P, Sarahla, Grace
SaraT, Anna, Rachel, Robin
PJ, Krisy, Lisa-Raquel, Deirdre
Bethany, Arthur, Najma, Patty
Danny, Kevin, Charlotte
Mom & Dad

♡ Kerry

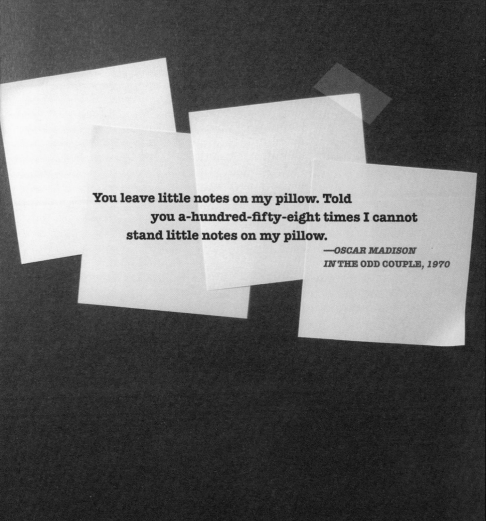

You leave little notes on my pillow. Told you a-hundred-fifty-eight times I cannot stand little notes on my pillow.

—*OSCAR MADISON*
IN THE ODD COUPLE, 1970

BACK

No one brings out my passive-aggressive side quite like my Grandma Cookie. It is the defense of choice, for example, when she calls to check on her annual care package of homemade ruge-lach—the one that arrived last year bearing the heartfelt note, "Enjoy, but don't eat too many!!" (Somehow, I had forgotten to send a thank you.)

Was I seeing Anyone Special? Was I watching my figure? Was I coming to visit this year?

Sorry, what was that? My voicemail is just so unreliable! I meant to call you back, but I've been so busy lately. I—oh, wait—I think I'm losing my signal . . . love you! Bye!

My mother says I have gotten off easy. When she was in college, Cookie liked to telephone her on Friday nights. If my mother answered, Cookie pounced. "Why are you home? Why aren't you out on a date?" she'd ask, before my mom could hang up. When she graduated law school—still unmarried—Cookie presented her with an inspirational needlepoint pillow she had made for the occasion. "You have to kiss a lot of toads before you meet a 'prince'!"

So perhaps it's fitting that my efforts to catalog passive-aggressive notes began with a first date. It was an early summer night at a dark bar a few blocks from the Brooklyn apartment I share with three roommates, in a gentrified neighborhood where the bars post signs reading: "No babies or laptop computers after 8 p.m." (The babies still come. Babies *never* pay attention to signs.)

After a few gulps of his beer, my date launched into

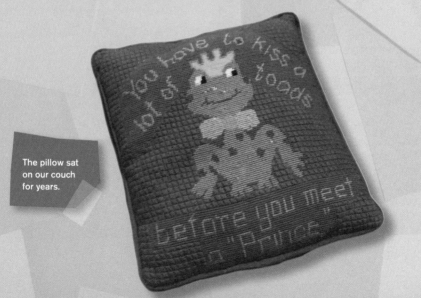

The pillow sat on our couch for years.

some light-hearted anecdotes about his slob of a room-mate—standard first-date small talk in a city where everyone has a story about a shady landlord or a neighbor with a penchant for fish fry and tantric sex. Apparently, things between this guy and his roommate had gotten so bad that they now communicated almost exclusively via Post-it note. It had started out with little things, like, Would she mind taking the trash out, just this once? But somehow it had progressed; first to pedantic cheerleading (*Just a helpful reminder: let's help save the earth by turning the faucet ALL THE WAY OFF! Thanks!*); and lately, to virtual declarations of war (*Would you mind keeping your fucking cat from urinating on the fucking carpet? Thanks!!!*).

Ah, yes, I said, I know those notes well. My current apartment had seen its share, most of them about the presence of unwashed dishes in the sink. They were usually signed with love; they were never addressed directly. I should start collecting them, I joked—put them on the Internet or something. Now *that* would be passive-aggressive.

Yeah, he said. You should.

I had been kidding, but now the idea tickled me. And so, back at home, a few gin and tonics later, I decided to do exactly that. I registered the domain name passiveaggressivenotes.com, and the next day, I started uploading: the dirty-dishes note from above the sink, an amusing noise complaint from our downstairs neighbors, the birthday card from Grandma Cookie.

Unlike our apartment's approach to dishwashing, the

response to passiveaggressivenotes.com was enthusiastic, immediate, and overwhelming. Thousands of notes poured in from shared bathrooms, kitchens, cubicles, parking lots—a unexpected bounty of thinly veiled bile—and with each new note I posted, readers from Topeka to Tokyo chimed in with their own commiserations, speculations, and exhortations. (Wrote one reader: "Instead of a single note, can I submit an entire person? Like my mother?") The experience was part voyeurism, part schadenfreude, part group therapy. (In retrospect, however, it would likely have been more therapeutic for me personally had I warned my note-writing roommate ahead of time. Oops.)

I wouldn't describe all of them as textbook "passive-aggressive"; some are downright aggressive in tone, while others are remarkably restrained. Of course, because the DSM-IV doesn't officially recognize passive-aggressive behavior as a diagnosis, even the textbooks are a little sketchy in their definitions of the term. But Dr. Scott Wetzler, a clinical psychologist and author of *Living with the Passive-Aggressive Man*, says that at the most basic level, passive-aggression is hostility gone underground—frustration expressed indirectly, even unconsciously, rather than through a direct confrontation. Passive-aggressive people—and the notes they write—display an "accidentally-on-purpose" ambiguity. Its barbed criticism disguised as helpful advice, a gentle reminder, a friendly joke—anger sugarcoated with pleasantries and smiley faces, but betrayed by one too many exclamation points.

Wetzler says this split between what is said and what is understood is what makes passive aggression so "uniquely crazy-making," and I think this contradictory quality is also what makes the written evidence of this behavior so compelling. Taken together, these notes are a revealing trip through our collective neurosis. The issues at hand may be petty and mundane (slamming doors, purloined Hot Pockets) but the notes themselves are often charged with the fervor of a spurned lover.

That first date, by the way, did not lead to a second. As it turned out, this particular toad was destined to be just another fateful sound bite in the hackneyed romantic-comedy montage of my dating life. (In this case, the sound bite was: "Oh . . . you're a *dog person*." When he followed this up with an extended rant about how dog-lovers were needy, emotional cripples who are intellectually inferior to cat people, I realized he wasn't kidding: this was actually a deal-breaker for him.)

But it wasn't all for naught. While I didn't get a new boyfriend out of the experience, I did get a blog, and now, a book. This is no consolation to my Grandma Cookie. She recently—apropos of nothing—offered to buy me a puppy if I would only get engaged. I admit, it was a tempting offer. At this point, though, I think I'd rather have a dishwasher.

—Kerry Miller

MY ESTEEMED HOUSEMATES,
I HAVE SOME UNFORTUNATE
NEWS TO REPORT. IT APPEARS
THAT OUR ONGOING EXPERIMENT
TO SEE IF THE DISHES WOULD
INDEED WASH THEMSELVES HAS
ENDED AND ULTIMATELY FAILED.
DUE TO MY APPARENT BAD MEMORY/
DEPARTURE FROM THE HABIT OF PLACING
MY DISHES IN MY ROOM/LACK OF
SUPERPOWERS THAT ALLOW ME TO
DETERMINE THE LAST USER OF SAID

DISH, I DECIDED THAT THE BEST
APPROACH WOULD BE TO WASH ALL AND
START THINGS WITH A CLEAN
SLATE. GIVEN MY TENDANCY TO
FREQUENTLY MAKE ELABORATE
GOURMET DINNERS, I CAN ONLY
ASSUME THAT MOST DISHES WERE
MINE ANYWAY. THERE IS NO NEED TO
CONCERN YOURSELF OVER ANY
MINISCULE NUMBER OF DISHES THAT YOU
MAY HAVE CONTRIBUTED; YOUR TIME IS
UNDOUBTEDLY OF GREATER VALUE
THAN MY OWN. I'M SURE YOU WERE
ALL CHOMPING AT THE BIT TO DO
YOUR FEW DISHES AND I JUST
HAPPENED TO BEAT YOU TO IT. I
ALSO HAVE GREAT CONFIDENCE THAT
THE LITTLE TIME IT WOULD HAVE
TAKEN YOU TO DO YOUR DISHES WERE
SPENT DOING MUCH MORE MEANINGFUL
AND IMPORTANT THINGS SUCH AS
ENJOYING A GAME OF YOSHI'S ISLAND,
WATCHING AN EPISODE OF PRISON
BREAK, OR PERHAPS READING SOME
CLEVER QUIPS FROM FHM. IF THERE
IS ANYTHING ELSE I CAN DO TO
COMPENSATE FOR THE ENORMOUS MESS
I CAUSE IN THIS HOUSE, PLEASE DO
NOT HESITATE TO TELL ME.
ERIC

P.S. I HAVE BEEN LOSING SLEEP
 OVER THE STATE OF
FREE, ACCESSIBLE SPACE IN OUR SINK.
DUE TO THE PRECARIOUS NATURE OF
THE SITUATION, I FEEL THAT AN
IMMEDIATE COURSE OF ACTION IS
NECESSARY. SO FROM THIS MOMENT
ON, I WILL BE REMOVING ANY DIRTY
DISHES AND DEPOSITING THEM ON
THE FLOOR OR OTHER APPROPRIATE
LOCATION IN THE HOUSE. MAY THE
SANCTITY OF THE SINK PREVAIL!!
P.P.S. MENTION MY
DISHES TO ME AGAIN, AND I WILL
KILL YOU IN YOUR SLEEP. XOXO
P.P.P.S. HOW'S THAT FOR AN
 INTESTINE, BENSON?

Chris—

Yes, the heat was on 60° all weekend. I was afraid about my hamster's health. Please write date + time for my death below.

DATE_____ TIME_____

Kill hamster too?
☐ Yes ☐ No

Chris has held on to this note from his college days in upstate New York for nearly two decades now, and the years seem to have given him some perspective on the situation. Chris now fully admits to being the apartment's "thermostat tyrant," always nagging everyone to turn down the heat, especially during school breaks. This note from his roommate was apparently enough to show him the error of his ways. After this, Chris says, "I did relax with the thermostat nagging, I think."

Universal®

D_____,

Surprise !!!
Clean Desk !!
Please make sure
your desk stays
clean + orderly

Thanks.

D

P.S. The stuff on the
red cart needs to go
back in supply room.
The stamps maybe
to the applicable
dept. ⟶

Hey Sweetie-Pie,
Let's go out to dinner
tomorrow. We miss you!
We don't have to.... if it's
too much trouble. No,
nevermind.

Love,
Mom ♡

Today is The
1 ST of July

An oh-so-subtle reminder
to pay the rent . . .

318
N 3 6

BO

... and a not-so-subtle reminder.

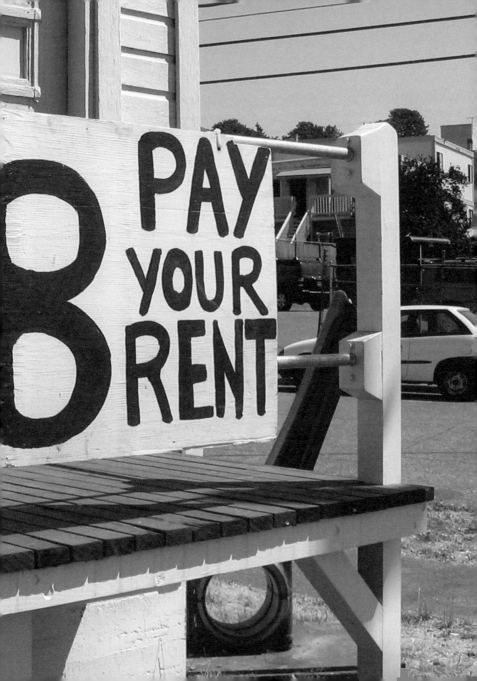

IF YOU DRAIN THE JOE, MAKE SOME MO'!

peanut gallery

NITPICKERS

Environmentally unfriendly

Pedantic

"Pedantic" is a sentence fragment, so it should not be capitalized

nope, it's an adjective

B.D.O.C.

Bio Degradable Organic Carbon ?

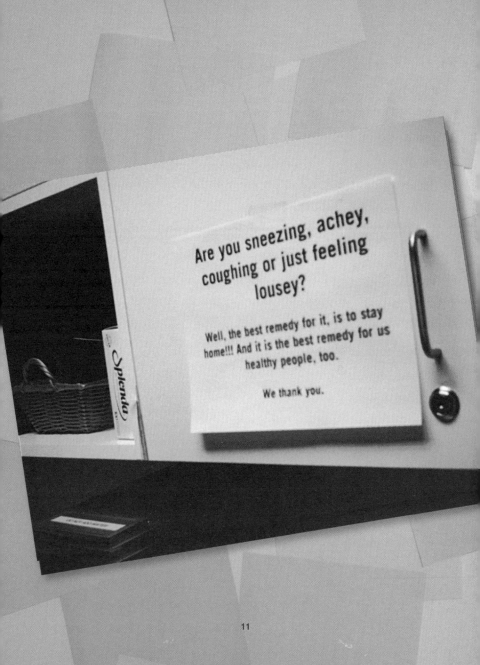

Are you sneezing, achey, coughing or just feeling lousey?

Well, the best remedy for it, is to stay home!!! And it is the best remedy for us healthy people, too.

We thank you.

DEAR NEIGHBORS:

I HAVE BEEN LIVING HERE FOR 3 YEARS NOW AND, IN THAT TIME,
I HAVE HAD THE OPPORTUNITY TO DISCUSS THE WEATHER WITH
EACH AND EVERY ONE OF YOU. ALONG THE WAY, WE'VE
ESTABLISHED A FEW FACTS:

WEATHER CHANGES.
OFTEN.
IT'S NOT ALWAYS WHAT YOU EXPECT.
SOMETIMES IT IS.
LIFE IS BETTER IF YOU ARE DRESSED
APPROPRIATELY FOR THE WEATHER.

I THINK WE HAVE, PRETTY MUCH, SQUARED AWAY
THE DEAL WITH WEATHER.

I WOULD LIKE TO OFFER A FEW SUGGESTIONS FOR NEW TOPICS
OF CONVERSATION:

WHO SPITS IN THE ELEVATOR?
WHO IS SHAVING THEIR HEAD IN THE STAIRWELL?
WHERE DO THE CRACKHEADS GO
WHEN THEY COME HERE?
WHY DOES PERFECTLY GOOD STUFF END UP IN
THE GARBAGE WHEN THERE ARE PEOPLE IN THIS
COMMUNITY WHO COULD REALLY USE IT?
WHICH PASSKEY DO YOU THINK
WE'LL BE USING NEXT MONTH?

THESE ARE ONLY SUGGESTIONS, OF COURSE...
I'M SURE YOU HAVE LOTS OF GOOD TOPICS TOO.
REALLY — ENOUGH WITH THE WEATHER;
LET'S GET TO THE NEWS.

July 9, 1992

Dear Dad,

You know I hate play-
ing the violin! Why are you
pushing me so much? I said
I wanted to quit. You said
"no." You know what? It's
not your dicion. You can't
force me to ruin my life
by making me take lessons.
Now I never want to touch
that thing ever again. I don't
know what you think but
I think the violin is stupid.
Very stupid. I never really
wanted to play the violin
anyway. I hope you under-
stand and agree with all
this letter is saying.
 Did you even think about
what I thought of the
violin? Did you ever ask?
Mom was willing to let me
take it back if I wanted.
Why don't you understand?
 Just don't get it.
 And the violin isn't
cheap either. You're paying for
something. That's making me
unhappy. I hope you think
about it. I've said all I
have to say.

 - Betsy

13

Dear fellow Christian,
The lawns of homeowners on
this street are not public parking.
Please "love thy neighbor" by
getting off my grass.
Thanks!

Yo, Dipwad!

Guess what?

Nobody is interested in stealing or breaking into your lame-ass Cherokee.

Please remove the annoying, hyper-sensitive alarm system as it serves no purpose whatsover.

Love,
The people sitting in Starbuck's

This note was slipped back under the door of the Starbucks with the words "soo what?" scrawled on the back.

TO Whoever stole my
" HOT POCKET " :

IT's NOT DONE
and
NOT NICE ''
‿

You are welcome to contribute

if you are enjoying the special blend coffee in Marketing on a regular basis.

Thank you—
the Marketing Department

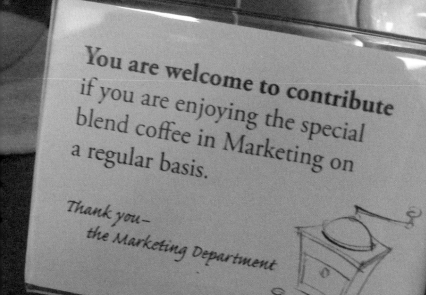

Hey, let's try a more simple coffee message. Thanks to the vast majority of you who continue to do what is right when it comes to making more coffee for everyone when you see it needs to be done! – Or, as noted, even the non-coffee drinkers who turn off burners when others don't do the polite thing and make more for others, preferring to leave tiny amounts of coffee in the bottom to burn up and turn solid in the bottom of the pot.

For that small group of folks who don't do what is right – you know who you are. We notice no one ever behaves badly when others are around. So, reach down deep and do the right thing! We really don't want to pour over all those videotapes to see who you are.....

10:30 a.m. and SOMEBODY has already left an empty pot on a burner and walked away!
UNBELIEVEABLE!!!

Can I trade this job for

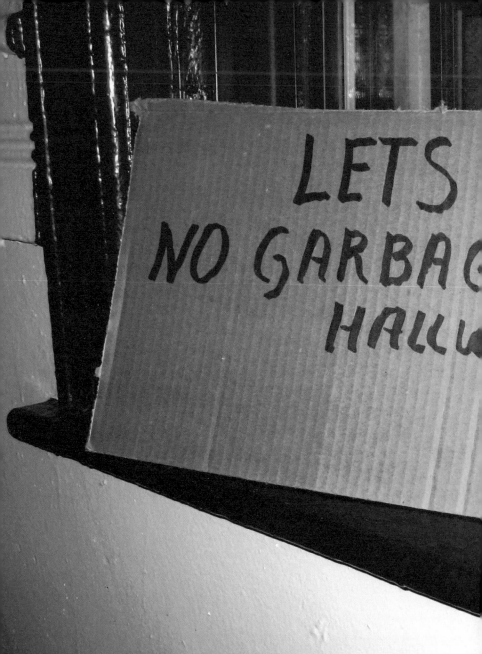

A

The Gas + Electric
is 84.00
H₂O 10.68
 94.68 total
 for
 Feb.

Hope all is well!
C____

P.s. I am having a
big party for
UNM students.
Fri eve.

Warning! They
may be noisy!
Tell us to shut up if it gets
too obnoxious. Also - your
welcome to come. (I don't think
its your kinda party though :)

"For the record," A says, "I wouldn't have gone to my landlady's stupid party anyway."

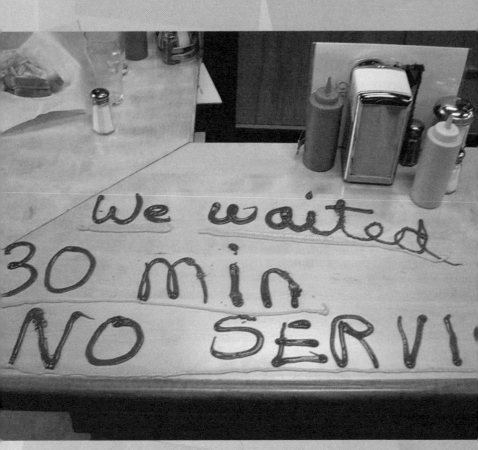

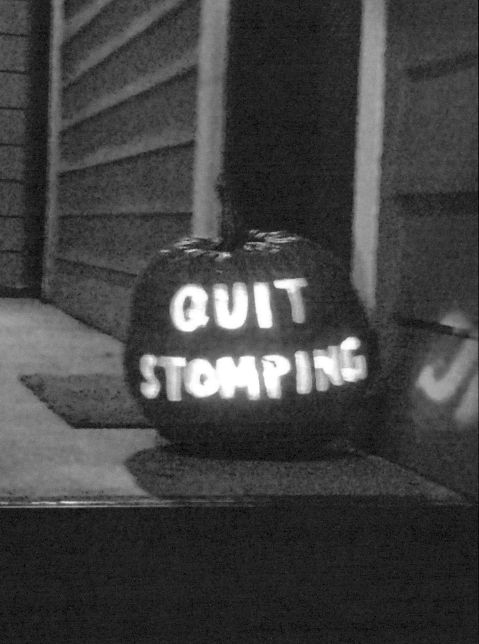

Teachers.

 We offer naptime as a service to our parents and younger children. After all, we all know growing bodies and minds need lots of rest. I understand that the long hours and darkness can be tempting, but laying down on the floor with a pillow may be frowned upon by parents entering the room; not to mention being against state regulations for the supervision of children.

 If you are too exhausted during the day, and you continue to fall asleep in the afternoon, feel free to come to me. We can discuss the option of cutting your hours back to a more appropriate smaller amount so you may get more rest. If that does not help the situation, I will be more than happy to help you find a night shift position. Unfortunately, we do not offer night shifts at this particular school.

 Happy to be of service,
 ♥
 L

Please inform the young woman in
your office that her dress is inappropriate.

M█████

I couldn't help but notice you haven't washed dishes once.

Is it b/c you don't know how? I'd be more than happy to show you!

—E████

If you do not know how to change the toilet roll using the spindle provided, or if you need directions to where we keep spare rolls, please see Hannah for a tutorial at your earliest convenience. Thanks.

Empty Roll.

Find...
(In cupboard
or upstairs
closet)

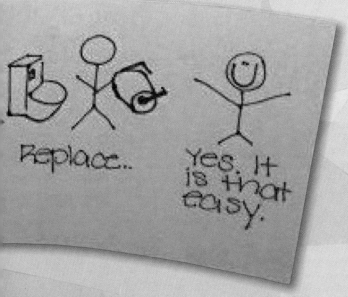

Replace...

Yes. It is that easy.

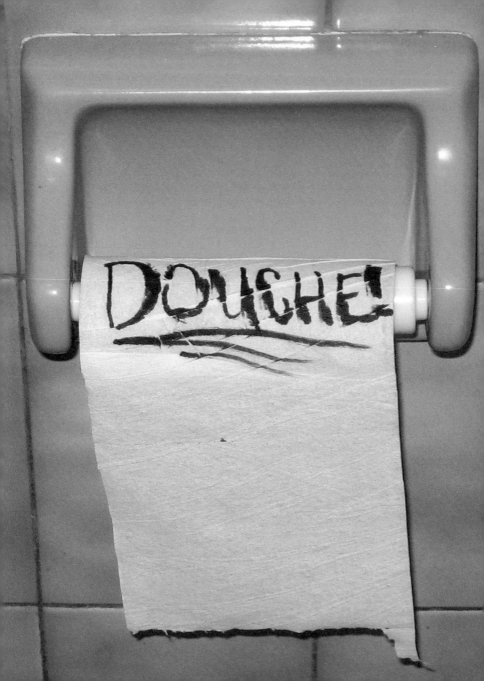

Dear Y█████,

PLEASE TURN ME <u>OFF</u>
BEFORE YOU LEAVE.
THANK YOU.

Respectfully & Forever
Yours,
 The Coffee Pot

Please clear any unused time off the microwave when you are finished. Some of us have O.C.D. and leftover time drives us crazy. -Thanks!

SENSOR COOKING

POPCORN BEVERAGE REHEAT

BAKED POTATO FRESH VEG.

TIME COOK AUTO/TIME DEF. TIMER

REMINDER HELP

GUIDE BEHIND DOOR

1 EXPRESS COOK 2 EXPRESS COOK 3 EXPRESS COOK

4 EXPRESS COOK 5 EXPRESS COOK 6 EXPRESS COOK START PAUSE

A.▓▓

I left these here in case you want them. If you do not, I am going to trash them so I thought I would ask.

Also, I wish you would leave my placemats out on the table. I know you don't like them but I do, and this house sometimes feels like it is full of your stuff while mine is crammed in my bedroom. I appreciate all of the thought you put into decorating but a few things of my own would be nice.

Last thing (I promise) I bought the bath mat while you were gone since yours is thin + it slides everywhere. So whenever you are ready to trash yours I have a new one.

Okey dokey. I'll see you later on... hope you had a fun day w/ your family!

(ps. Text me at work if you need blah !!)

"I was putting away her placemats to clean up . . . but also because they are the most hideous things I have ever seen." —A., *Austin, Texas*

BORROWING
A PEN? ♡
please put it
back, or I will
(expletive deleted)
you up! ☺TW

Valentine's Day!

don't worry

NOVEMBER
27
TUESDAY

NOVEMBER
S M T W T
1 2
4 5 6 7 8 9
11 12 13 14 15 16
18 19 20 21 22 23
25 26 27 28 29 30

OCTOBER
S M T W T
1 2 3 4 5
7 8 9 10 11 12
14 15 16 17 18 19
21 22 23 24 25 26
28 29 30 31

DECEMBER
S M T W T
2 3 4 5 6
9 10 11 12 13
16 17 18 19 20
23 24 25 26 27
30 31

NT
specting an
hibiting the
the freedom
right of the
d to petition
grievances.

job
o give

ossible
the
u."
ew Sullivan,
(U.K.), 2006

DOM FORU
. FREE SPEECH. FREE

Ext

NOOB

Roommates, 6/20

As stated in the beginning, I do not mind you using my kitchen utensils, as long as you wash them and **Put Them Away**. I want to reinforce this with a reminder to <u>THOROUGHLY</u> wash them and put them back in their proper place <u>*IMMEDIATELY*</u> after use. Not the dishwasher or leave them out to dry. I am trying to be generous, and it is frustrating that I can't even use or find my own dishes when I would like to. Also, please remember to get paper towels when you shop or reimburse those who already do. Thank you in advance for your cooperation.

~Alicia

Microsoft Dynamics NAV USER GROUP
www.navug.com

WITH WHOM AM I SHARING
MY INSTANT PORRIDGE?

CAN WE SET UP A 'PORRIDGE
'POOL'?

A SMALL CHILD ANSWERING TO THE
NAME OF GOLDILOCKS WAS SEEN
LEAVING THE OFFICE EARLIER TODAY?

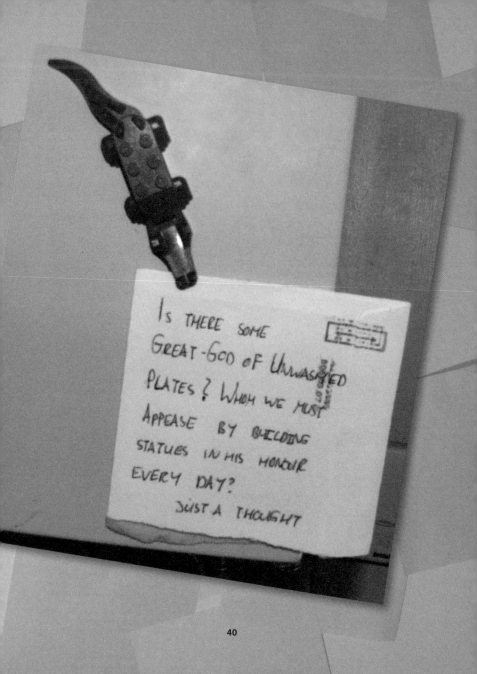

WHO IS THE
ASSHOLE WHO
KEEPS EATING
THE TRADER JOE'S
SUSHI IN THE
FRIDGE?

Who is the
asshole who
keeps leaving such
delicious sushi
in the Fridge?

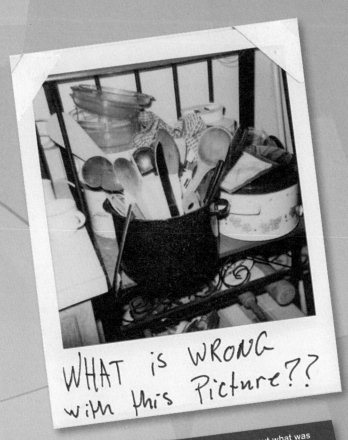

WHAT is WRONG with this Picture??

"I stared at the picture for a long time and still couldn't figure out what was "wrong" (the (extremely dull) knife in the front of the container was put in point-up). It would have taken about 0.5 seconds to just turn the knife around; how long did it take to get the camera, take the pic, wait for it to develop, write on it, and find athletic tape to stick it to the counter?" —Scooter, Boston

Hey –
Did you ever think
that the silence in
this room is due to
YOU not initiating
a conversation?
Don't rely on me for
everything.
— Your EXTROVERTED
Roommate

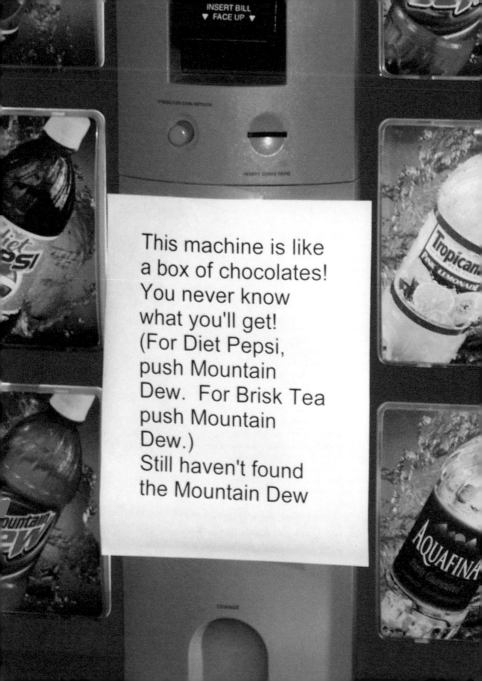

ruit

CONTENTS

1 Peck
8.81 L

You
you
May bl
(toxic free

I _____ 's Fruite

This fruite is _amazing_ BUT

is XtoxicX to those

aren't named

ask T. _However_ if

(313) if

have a peice she

you with it!

permission)

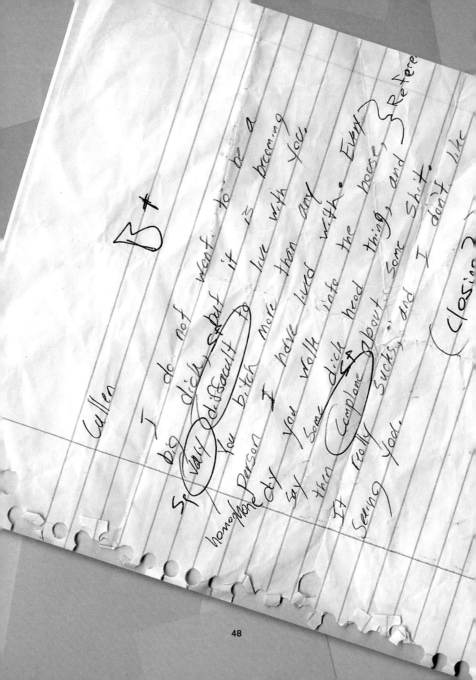

e me

after class

49

12-23-03

Dear girl(s), ①

When I 1st moved here, I took the initiative to be nice to you & try to get to know you. You guys are the most childish group of females that I've ever known. Really. I don't know if you're intimidated of me, or if you're racist, but you need to straighten up your attitude. I knocked on your door to tell you, "sure, I'll cut the light off," but, you acted like you didn't hear me. So, since you don't hear my knocks, I don't hear your request. I don't understand how you would expect me to ~~leave~~ the light off, when you won't even answer your door! What kind of sense does that make? Are you trying to prove a point? I would advise you to stop slamming your door, & to stop

②

yelling out rude remarks. Be a woman & talk to me face to face. I don't have time for the little games that you're playing. You don't know me, & the way that you're treating me is not cool. I deserve respect, & I _will_ get it. I am a very peaceful Christian girl who works 2 jobs, & goes to school. I'm not out to hurt anyone but for some odd reason you're out to hurt me. I would like to know why. You are very phony, & now I really dislike you. If you have a problem w/ me, you need to address it in a more mature fashion. You have a mouth, USE IT! I don't know why you don't answer the door when I knock, are you scared or something?

The 1st time I knocked on your door, I was offering you some items that I didn't want, but you still acted like you didn't hear me (& I know you were there). You guys have done a lot of things that I dislike, but I still respect you as my neighbors. You need to start doing the same or I will take further action. Stop slamming your door, & stop unlocking my door roughly!

Keeping on that light is wasting electricity. I was going to leave it on until you ignored my knocks. Why did you do that? Are you deaf? I don't think so. I just turned 19, & I'm thinking that you should act more mature being older than me, but apparently not.

I appreciate your concern, but I can turn off my own lights. You don't have to worry about them.

___, charlottesville, VA

So I live with these girls, + share a bathroom with a particularly ornery individual, who loves to leave all the lights on. Well as long as I pay part of the electric bill, her lights are my concern.

P.S. So she hates me because I have loud sex.

BEFORE YOU DECIDE TO TURN THIS OFF, CONSIDER THAT MAYBE SOMEONE WOULD LIKE TO BE ABLE TO SEE AS THEY CARRY THINGS DOWN THE STAIRS. IF YOU DONT LIKE THE LIGHT... SHUT YOUR EYES?

Dear Pizza theif,

I hope you enjoyed those two slices of Dominoes pizza. I did. It was so nice in fact I kept it in the fridge to enjoy again.

So it was my surprise to find those slices missing the next day. My mum bought me that pizza - but I guess you must have been in dire hunger to eat my food. In that case, that's alright. At least you cleaned the side plate afterwards.

But I will still kill you.

C

hey darlings! ♥✱✱ ～
You know we all love you
Soooo much, but as your
floormates we have some
concerns.
 1. music is great, but
 TURN DOWN THE VOLUME !!!
 2. doors are meant to be
shut, NOT SLAMMED.
 3. I know your relationship
is rocky, but we don't need to
hear you fight, KAY?.

LOVE YOU! The lovely
 kiss kiss, ladies of your
 floor ♥

dear lovely ladies of this
room: We appreciate &
sympathize with the fact
that your door is heavier
than others & slams
easily. However we only
request you follow the
campus policy of 24 hour
courtesy: STOP SLAMMING
So that all the rest of us
can get the hours of sleep
we need to stay as lovely
as you. ～
Many Thanks, XOXO
The ladies on your floor ♥

HEY GIRLS! ♥～.
THIS IS A MIRROR.
NOT A PAPER TOWEL
So WIPE YOUR DIRTY
HANDS SOMEWHERE
ELSE!

thanks sooo so much!
 LOVE y'all!!
～ MWAH. ～～
the ladies of your floor. ☺

dear lovely ladies of this room,
we totally understand you have
such a hard situation with
your super heavy door but
the rest of us need to get
our sleep so please STOP
SLAMMING. remember, our
campus has a policy of
24 hour courtesy! thanx
sooo much for cooperating.

much X♥X♥,
LOVE! the ladies of your floor.

NOTE TO SELF:

IF IT'S TOO HARD FOR YOU TO
CLOSE THESE DOORS,
MAYBE YOU SHOULDN'T BE
OPENING THEM. *ooo sassy!*

OK, WE GIVE UP!

Go ahead and LEAVE THE DOOR OPEN!!!
We <u>WANT</u> all the **RATS, POSSOMS, BIRDS, LIZZARDS, RABBITS** along with all the **VAGRANTS, THIEVES and LOCAL SKATEBOARDERS** who like to burn up our microwave ovens, to just come on in!!!!!
(Added Tuition Fees Should Cover It)

Thank you for your assistance!!!

It is Ok to steal food from people (I'm aggerating); but I am a MOTHER-TO-BE who starved because you took a bite out of my lunch meat and cheese.

Feel free to starve me, but not my baby!!!

If you are in this building, you must have a job...so buy or bring YOUR OWN FOOD.

IT IS NASTY TO PUT BACK THE FOOD YOU ATE OFF OF!!!

LEAVE OTHER PEOPLES FOOD ALONE!!!

IF YOU NEED TO FIND A PLACE THAT WILL PROVIDE YOU WITH FUNDS TO EAT OR A BUDGET TO PROVISION PROPER FOOD ALLOWANCES, THERE IS HELP FOR YOU ALSO.

PELASE DON'T LET ME CATCH YOU STARVING MY CHILD (UNBORN OR NOT) BY TASTING, EATING, OR STEALING MY FOOD

I DO NOT SPEAK FOR JUST ME. IF YOU DID NOT PUT IT THERE, DO NOT EAT IT.

Regards,

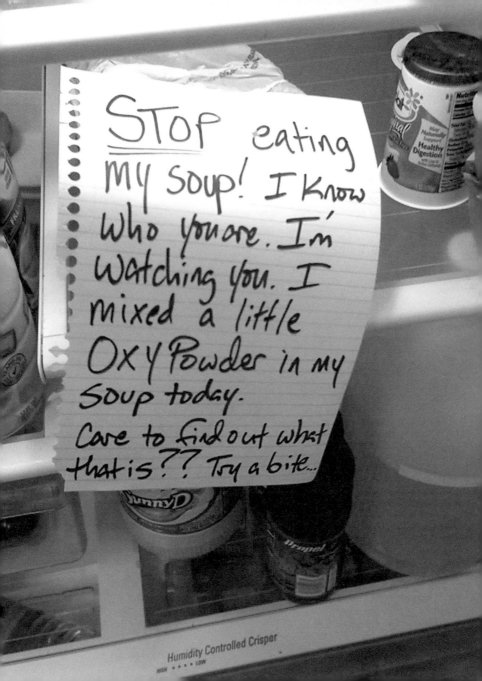

not I'm tired of
 it
no more smoking
for no one not at
all but me and my
room is no smoking
room or using me
for a place to smoke
your cigarettes at no
more my room is
my room and no
one else's room so
don't demand me what
to do in my room
either Janice

PRIVACY

- If you are approaching someone's cubicle, respect that.
- Resist glancing into other people's cubicles as you walk by.
- The cubicle is someone's work area and should be treated as such.
- Your neighbours cubicle should never be treated as a supply cabinet
- If you have valuables at your desk, lock them up.
- The cubicle is a private area for that employee.
- Your neighbor should have the privacy to conduct business without worrying about a non-employee listening in on what they are saying.
- Should you happen to overhear private or confidential conversations, pretend that you never heard it at all. More importantly, don't repeat what you heard to others.

NOISE

- Use conference rooms for meetings
- One mans music is another mans noise
- Do not use screen savers that make noise
- Do not have "gab" sessions at your workstation

"SMELLS"

Just because it's your cubicle
Does not mean you can take off your shoes!

- Remember, what may smell good to you may be pungent to someone else.
- Be cautious about wearing too much perfume or aftershave. Some people may suffer from allergies.

Please don't forget
the bathroom!

Also, if you could replace
even 1 roll of paper
towels, that'd be great.
Thanks!

(I left the mop out for the
Kitchen + bathroom)

Can someone
please take
the trash out...
I did ^all the dishes.
Thanks,
♡ Natalia

P.S. Cockroaches
may start migrating into
our kitchen for the winter

GLAD U HAVE GREAT SEX
LiFE but we think it's
Time to Replace yr old bed
DEAR, SOUND AWFUL when
U Have sex also U might
need ViAGRA mate coz
We can heard seem took
U so long to get it up
& Done with it !!

YR NEIGHB

YOUR OLD SPRING BED
VERY NOISY WHEN YOU
GUYS HAVING SEX!!!
WE DONT CARE HOW MANY
TIMES /day U HAVE SEX
BUT WE JUST DONT WANT
GET DISTURB WITH THE NOISE
OF YOUR HORRIBLE OLD SPRING
BED. GET RID OF IT OR
SEEM YOUR BOYFRIEND HAVE
TO LOST WEIGHT. IF U BOYFRI
CANT AFFORD IT To buy U a new
BED, MOST GET RID OF HIM AS
WELL DEAR.

WE DONT CARE when U
have SEX but the Sound
of YR old bed veRy
DISTURBING !!!
might best just put yr
mattRes on the flooR,
then you can have sex
every day without disturbing
your neighbour with that
awful sound of spec yr
old spring bed !

SEX iN 20/60

IF you sleep often get
Disturb especially like
last night between 1-3 am
caused by sex marathon
6 times /2hrs, wonder if
room 20 using drug eg:
ECSTAsy. We dont want
any drug user disturb our
sleep in the middle of the
night /our peace at all
times.

12-14-06
4:00 am

Hi !

I have a concern regarding the
odor that regularly permeates the common
ventilation system in the apartments.

Having a 30+ year health professional
career, I suspect illicit drug use which
is affecting my own air daily and nightly.

I sincerely wish you (all?) the best
in life and perhaps in dealing with a
possible personal issue. However, I must
confess I am not willing to let this
"passive abuse" of my own rented home
to continue quietly.

Just letting you know - if there is
drug use going on that affects other
tenant's right to clean breathing, other
steps may be taken to ensure it.

I hope this will not be necessary.
It's your choice. Best of luck, and a
lovely holiday season to you and yours.

Take Care...
Concerned Neighbor

In her own defense, says Amber, the
recipient of this note: "I don't do drugs. I don't
even smoke cigarettes!"

FOR THE LOVE OF GOD,

STOP BURNING
THE POPCORN!

Dear ▬

While I am happy for you, in that you have found new "friends" by play World of Warcraft, I am concerned that, by never getting up from your computer that 1) you will go insane, 2) the smell will never stop permiating under your door and 3) that you will never shower again. My actual friends allow me

leave them every once a while to, you know, shave, poop, wash and take out the garbage. Of course, other than that, I, like you, spend EVERY WAKING MOMENT WITH THEM.

Get a life,

For your sake,

▬

Sometimes people like to sleep at midnight. Not that your stories about people getting drunk aren't fun but perhaps you could go to your friends room for once and keep them up all night.

If this is not possible then simply shut up!

"I think the thing that makes it really passive-aggressive is that the note writer slid this under the door, rather than asking her suite mate to be quiet face-to-face, and then refused to come out of her room to talk about it."
—Mitch, London, Ontario

This is to inform you the tenant who lives on floor _____ appears to be having drug and alcohol problems. She arrives home (by automobile) every morning between 4:00 – 4:30 A.M and can barely drive or walk. She has a parking spot on the first floor of the garage. We/You are lucky to our knowledge nothing or nobody has been hit.

This morning, she was escorted home by a gentleman and could barely make it to exit from her parking spot in the garage. She was regurgitating to no extent all the way. In our garage that we paid for!!! One can only wonder what the elevator and hallway were like for our cleaning crew and tenants.

Many times is she blasting her music at any given hour and the hallway reeks of substance. She has traffic in and out of her unit all of the time (at all hours). It's worse enough for those of us who OWN and pay our large assessments having to deal with those awful three people living together as section eight on floor #9, let alone having to deal with a substance user and player!

We ask that this is addressed immediately to avoid further escalation, i.e.; The Board, ████████████, the Police and all Tenants.

As much as it takes, this issue will be resolved!

Sincerely,
Condominium Owners

T., the "player" in question, says this note's allegations are more than a bit exaggerated. "I have never (that I can remember) regurgitated in the garage."

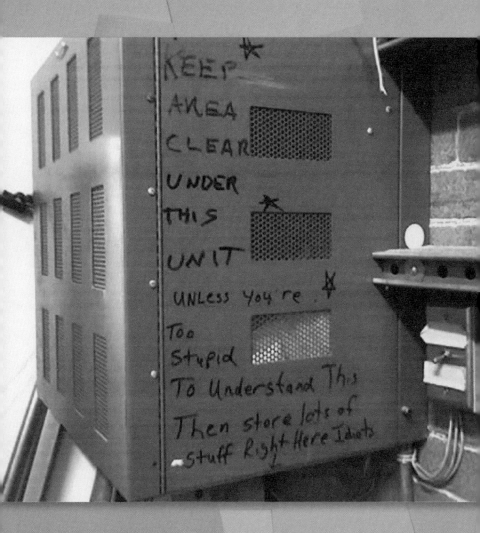

KEEP AREA CLEAR UNDER THIS UNIT UNLESS YOU'RE TOO STUPID TO UNDERSTAND THIS Then store lots of stuff Right Here Idiots

WE WISH THE PEOPLE WHO ARE TURNING

OFF THE HALL LIGHTS WOULD GET A

LIFE.

Dear #2534,

If your dog continues to bark past midnight, I will break into your home, steal it, and feed the little fucker to the homeless on Pearl Street.

— Happy Holidays,
RF

Now, I don't know if you know this about apartments, but did you know that you have to have 80% of your floor covered with carpeting? The reason why I know this is because my mom is in the real estate business! You should have someone in both of your families whose in real estate, then you might know more! The blonde might not know because she's a blonde and you know what they say about blondes? Their dumb and stupid! Now as for you mister, you probably don't have any balls because if you did then you would be respectful of your neighbors!

Have a nice day now and remember don't be scrooges!

Your "Friendly" Neighbor

P.S. – Just think of my roommate and I as the neighbors who like it quiet!

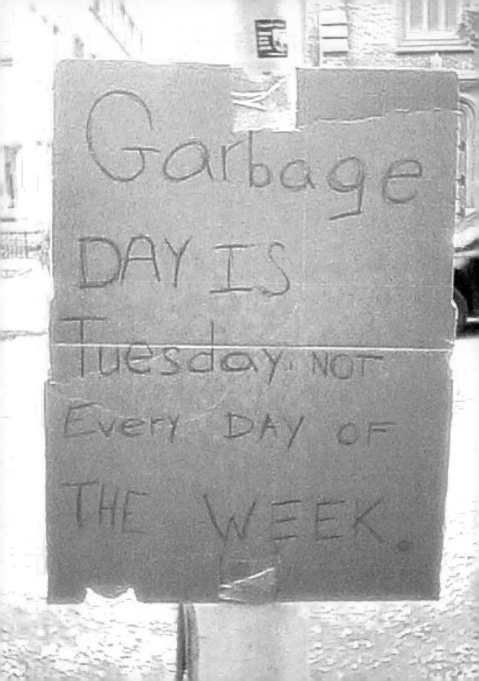

THIS IS A TRASHCAN. IT IS NOT A RECYCLING BIN. IF YOU TURN AROUND, YOU WILL FIND THE RECYCLING BIN SANDWICHED BETWEEN THE FRIDGE AND THE COFFEE POT. THERE IS REALLY NO EXCUSE NOT TO RECYCLE WITH IT'S SO ACCESSIBLE. YOU'RE KEEPING WASTE OUT OF LANDFILLS AND TAKING A SMALL STEP TO HELP SAVE THE ENVIRONMENT.

ATTENTION:

Please do not run the A/C with the window open.

An air conditioner is a reverse heat pump. It does not "create" cold; it merely removes heat from the air before blowing the air into the room. This heat must be deposited somewhere; for a window unit A/C heat is deposited _directly outside_ the window. Since the A/C is not 100% efficient, the net effect of running the A/C with the window open is to make the room _even hotter_ in the long run due to the accumulation of waste heat.

Window unit A/C

Cold Air

outside

inside

Very Hot Air

open window

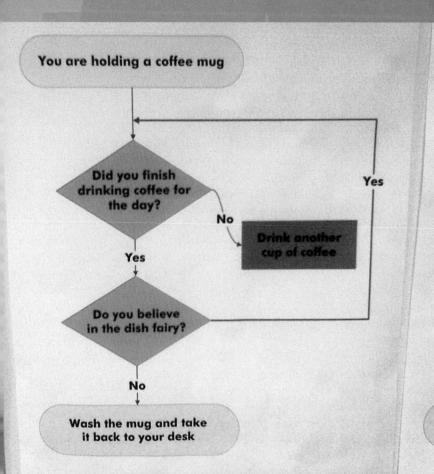

You are holding a coffee mug

Did you finish drinking coffee for the day?

No → **Drink another cup of coffee**

Yes

Do you believe in the dish fairy?

Yes

No

Wash the mug and take it back to your desk

Please refrain from leaving piles of work and/or random things on my chair when I'm away!

- It makes me want to poke my eyes out !!!!

♡Thx

I am not sure what
you people are up to,
but it is getting too loud.

You might jeopardize your
opperation by causing somebody
to call the police.

Just keep it down

Anonymous

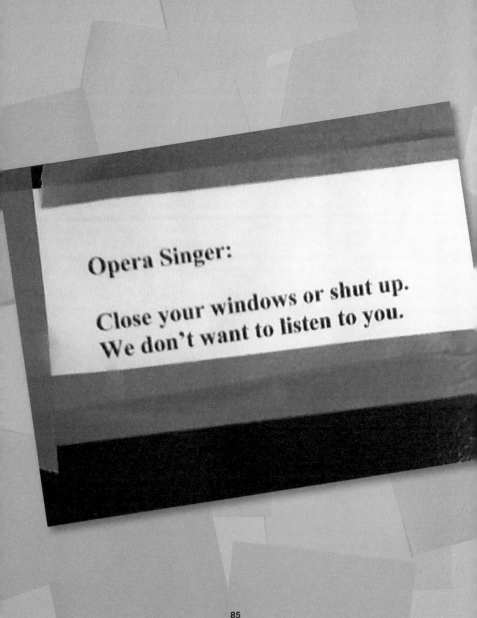

Opera Singer:

Close your windows or shut up.
We don't want to listen to you.

I think we should have our own cupboards and sides of the refrigerator and freezers. I've been asking around to other people with roommates, and they all seem to do this. I feel like what little groceries I buy are not solely being consumed by me. I don't buy slimfast for you to be on a diet, I buy it so I can be on a diet. Same with power bars. I had bought a loaf of bread not to long ago, and you had a loaf of bread in there too. I only used my bread twice. And your loaf was still there. You bought yourself some slimfast, and I bought myself some, but you seem to be using mine. Basically our groceries need to be separate. What I buy is mine, and what you buy is yours.

We need to also designate certain chores for each other. And keep the common living area respected and clean i.e. living room, kitchen, laundry room, and bathroom. How ever messy we want our own rooms to be is fine, but the shared common living area should be respected. And things. Like my couch, I've protected as much as I could from Malice. But my couch is expensive and I would like to keep it nice. So please when you put your shoes on and take them off, don't put your foot on the couch to tie/untie or zip/unzip. I noticed on the top back right corner that the material is bent down and starting to fray. And when you get up from the couch if you could just put the cushions back in place instead of leaving them all scattered about. I like sharing my things with you, but please just be respectful of them.

And how many pairs of shoes do you need out? Two or three pairs is understandable, but six? Just simply put them back in your room. Just as you took them out they can just as easily be put back.

I know that I am probably a hard person to live with, but I just like to respect my things and keep them nice. And I am all up for anything you have or need to say about the way I live. And if we can't compromise then maybe we aren't ment to live together. But I know that's not the case. So hopefully we can set some time to sit down and talk.

12-11-02

K██████,

Blockbuster Video called me about a Band of Brothers DVD rented on November 30th. They need it returned. It's very much past due. It will go on my credit report if not paid & returned. Thanks. Please be more responsible about these type of things from now on, especially when it's not your credit at jeopordy here. You need to prioritize your priorities. If you have enough time to hang out w/ Dane, you definitely have enough time to return a rental. Or give it to me and I'll <u>make</u> time to return it.

Thanks,
M████

I don't know what the 1-900 number is either. Could that have been the week of the warped tour then your mom was here or when Rachael stayed? I never use the house phone at that time ot night because I'm either sleeping or use my cel. So I think we should be it. Also only 20¢ of the longdistance & zoning calls are mine. $84.62 is yours. And $1.71 late fee is not my fault. You are the one who paid the bill late. Nonetheless I'm still going to give you ½ of the phone bill. Your welcome.

K

Would you please clean your
glitter hair spray off of the wall?
I'm sick of always cleaning
your messes up for you. If
you want to live like that then
I suggest to live with somebody
else because we've had this
discussion before. And I don't
want to nor do I have to live
with a lazy person who can't
clean nor share the cleaning.
You need to contribute a little more.
You are not just renting a room.

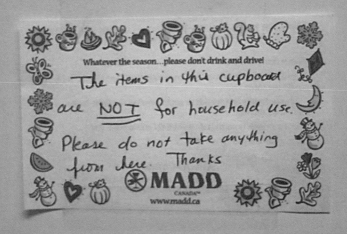

Whatever the season...please don't drink and drive!

The items in this cupboard
are NOT for household use.

Please do not take anything
from here. Thanks

MADD
CANADA™
www.madd.ca

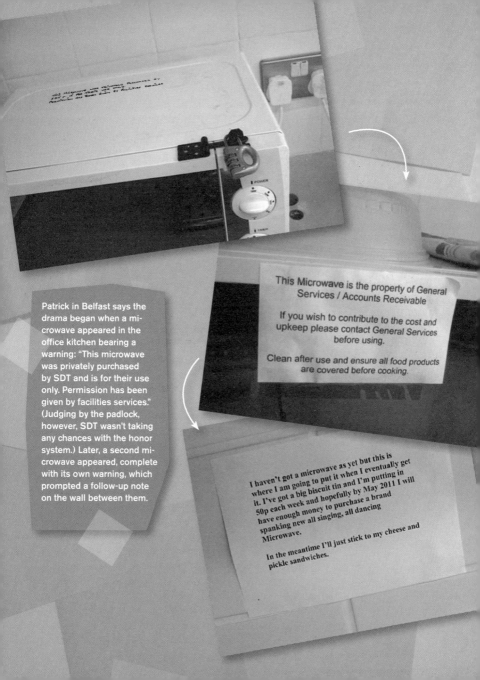

Patrick in Belfast says the drama began when a microwave appeared in the office kitchen bearing a warning: "This microwave was privately purchased by SDT and is for their use only. Permission has been given by facilities services." (Judging by the padlock, however, SDT wasn't taking any chances with the honor system.) Later, a second microwave appeared, complete with its own warning, which prompted a follow-up note on the wall between them.

This Microwave is the property of General Services / Accounts Receivable

If you wish to contribute to the cost and upkeep please contact General Services before using.

Clean after use and ensure all food products are covered before cooking.

I haven't got a microwave as yet but this is where I am going to put it when I eventually get it. I've got a big biscuit tin and I'm putting in 50p each week and hopefully by May 2011 I will have enough money to purchase a brand spanking new all singing, all dancing Microwave.

In the meantime I'll just stick to my cheese and pickle sandwiches.

To whom it may concern, 9/10/07

Please don't eat my pizza.
I know you enjoyed my little kahuna
last time, but I would really like
to be the one to enjoy it on
Wednesday for lunch.☺ You can
purchase one at Hideaway for only
$6.31 (including a salad w/ your choice
of Dressing) They deliver & pick up
orders. So if you are tempted to eat
this call 405-372-▓▓▓▓ &
GET YOUR OWN ☺ Thanks
 HC

A

YOU DON'T KNOW ME... AND TO BE HONEST I DON'T THINK YOU WANT TO... BUT THERE IS AN ISSUE THAT I NEED TO ADDRESS WITH YOU...AND I'M NOT GONNA BE PASSIVE AGGRESSIVE ABOUT IT..

IT HAS COME TO MY ATTENTION THAT YOU HAVE TAKEN THE WHITE BOARD THAT I GAVE !!!

AND THAT ANGERS ME!!!

I AM NOT A CHILD AND DON'T PLAY CHILDISH GAMES SO LET ME PUT THIS AS SIMPLE AS I CAN... DON'T TAKE SHIT THAT DOESN'T BELONG TO YOU!!!

I AM WRITING THIS TO YOU TELLING YOU TO GIVE HER SHIT BACK BEFORE I HAVE TO TAKE MATTERS INTO MY OWN HANDS AND GET PEOPLE INVOLVED THAT DON'T NEED TO BE IN THIS...

THE NEXT STEP IN THIS LITTLE GAME IS TO GO TO OUR HOUSING AUTHORITY AND I DON'T THINK YOU REALLY WANT THEM TO KNOW ABOUT YOUR SKEEZE BALL BOYFRIEND LIVING WITH YOU...OR HAVING TO DEAL WITH THE PENALTIES AND FINES THAT COME ALONG WITH YOUR IGNORANT ACTS!!!

SO STOP BEING A CUNT AND GIVE US THE BOARD BACK

IMMEDIATELY

THANKS ☺

YOUR SECRET ADMIRER

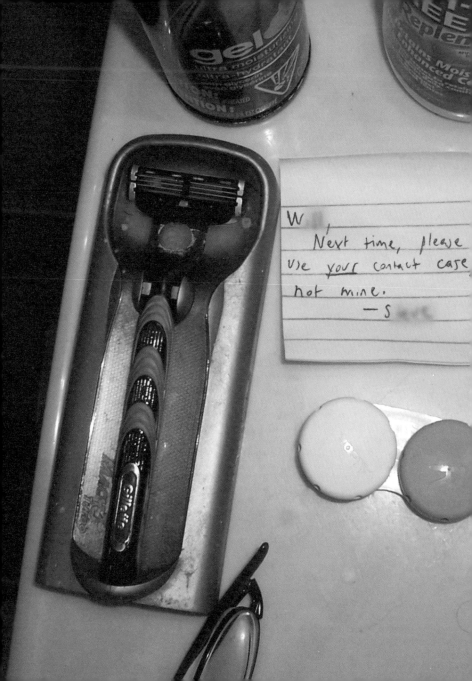

Work Order ID: 55216

Description	Please locate stolen can of nutritious V8 vegetable juice cocktail. Can was last seen at approximately 2pm Tuesday, December 6, in Lathrop fridge door compartment.		
	Missing 12oz of V8 may result in hazardous office environment.		
Location	████ Physical Resources	Building	
Area		Priority	High
Area Number		Craft	
Custom Category		Type	
Status	Complete	Estimated Hour	0.00
Assigned To		Requester	████
Estimated Start	12/7/2005	Request Date	12/7/2005
Est. Completion Date		Req. Completion Date	
Budget Code	53155	Purpose Code	Pest Control
Project Code		Project Description	
Equip Item No.		Equip Desc	

Budget/Code Assignment

Project Code	
Project Description	
Status	Complete
Status Last Change	12/7/2005 5:20:58PM
Budget Code	53155
Budget Description	████ Building Budget (excluding trailer)
Purpose Description	Pest Control
Priority Description	High
Group	
Classification	
Type	
Equipment Item No.	
Equipment Name	
Assignment To	
Action Taken	processed 12/7/05 message taped to refrig.

INTEROFFICE MEMORANDUM

TO: MEMO TO STAFF
FROM: OFFICE MANAGER
SUBJECT: DO NOT TAKE THE LUNCH OF OTHERS!
DATE: 03/29/07
CC:

Today a staff member reported that their lunch was taken from the refrigerator in our kitchen.

REMEMEBER!

> Remember to write your **Name** and the **Date** on every lunch bag you put in the refrigerator.

> Remember; make sure that you take your lunch and not someone else's.

> Remember; if you accidentally take another person's lunch, return it to the refrigerator immediately. Do not wait.

> Remember; if you deliberately take someone else's lunch, **shame on you**. Be kind and leave the lunch of others alone.

> Remember do not steal; it is not worth losing your job.

Thank you!

Jesus

doesn't steal Poptarts.

NEITHER SHOULD YOU...

you know who you are.

Dear Sinner,

I specifically wrote on the box of Starbuck's Frappucino bars Don't <u>Touch</u>! But did that stop you. No instead you took the liberty of taking my last one! I expect to see one in replace of the one you took by the end of the week! I know who you are so if you don't, I'll go to the CRE about it!

♡ A

PLEASE
DON'T SLAM
THE TOILET SEAT.

EVERYONE
CAN HEAR YOU
AND WE CALL YOU

"THE SLAMMER".

plus: we actually know who you are!

thx *Everyone* :)

NTINA

05/16/2007 7:40:53 PM Approved

Table# 101

d No:

n Code:

Date:

91614A

0808

Tran# 115109

Visa

unt:

$15.34

Tip: Boo.

YOU FAIL

tal: 15.34

STORE COPY ***

Band #1 —
 Thanks for playing
tonight. I really enjoyed
your obvious lack of
musical talent. It also
really helps to play
your bad music really,
really loud.
 Give me a call
THE LIMITED
sometime.
 M

FAQ: The Person who lives in the Top floor Flat.

Don't think I haven't seen you and your friends "pervving" at me and my boyfriend when we're in my bedroom. Do you think we are blind? Or maybe you're just so short-sighted and haven't got a good view. Do you spend your day hunched over a PC in a sad office typing memos to council officials? Maybe that is why you are forced to use binoculars. We've seen you!

Isn't it bad enough that you dump rubbish bags outside our door and the wall (on the wrong collection day!) that you now force us to cover up and turn the lights off when have sex.

Shame on you... and shame on your fat balding friend (who we also saw last night standing near your kitchen).

Just leave us in peace otherwise we will call the Police and take this further.

Signed:

The couple in the window opposite.

We're looking back too.

tenants
because of certain tenants
and their children the
windows in the hallway on
the ground level are closed
because certain people allow
their children to hang out
and throw food and other
items out of the windows.
i am fighting a battle in the
basement,ant's,and fleas.
i got rid of the fleas but it's
hard with people feeding
them.
so im sorry that the windows
are closed, that's the only
way to keep the yards clean.

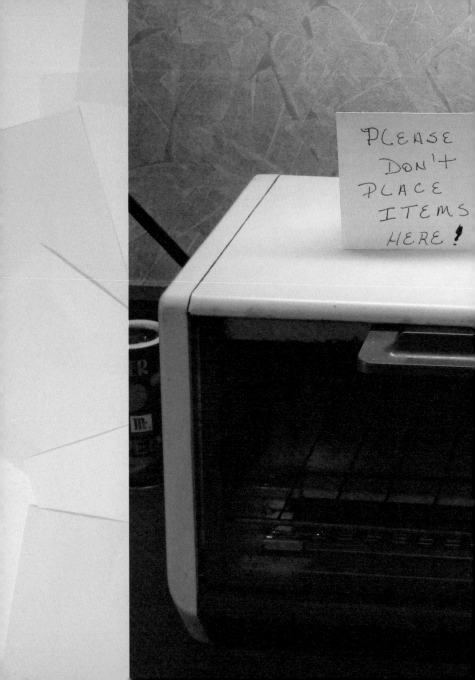

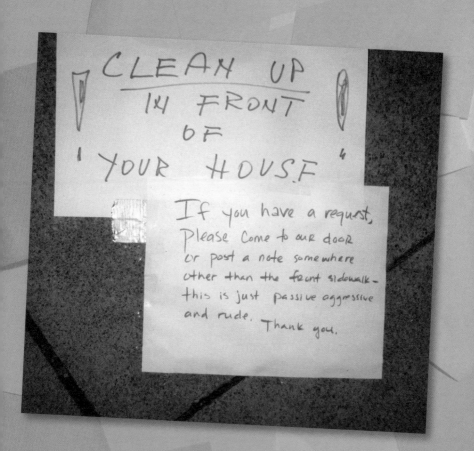

ooh! you said "damn!"
look out! you must
mean business now!

INTERNATIONAL PAPER

Buy your
own damn
toilet paper.

Pig,

It's clear that your parents never taught you things you
should've learned as a 5 year old, so let me help you
out. Let's start with some basic bathroom etiquette:

1) Flush the toilet when you're through with it.
 You might enjoy looking at your shit, but others
 probably don't. Congratulations on actually getting the
 shit into the toilet, though. That's an excellent start.

2) After the toilet has been flushed, wash your hands.
 You can't even work at McDonald's without learning that.

3) After you take a bath, drain the water. This is
 especially important if the water happens to be putrid
 and slimy and brimming with a disturbing amount of
 body hair.

Pig,

Although the thought of spending
the next few years of my
life wading through your piss
is delightful, I wasn't really
planning to pay for your
electricity too.
If you haven't paid your half
of the bill by Monday, I will call
ConEdison and have the electricity
shut off.

The air also doesn't have to be 80° as if we are in a sauna. If you keep it at 70° on Auto, it will circulate the air! Thanks,
The Apartment

yes it is hot outside
during the day.
No the air does
not have to be
on 70° at night.
Just open your
window.
♡ the Apartment

h

Now I realize that you _may_ have temporarily lost your _conscious sense_ of things, _however_, please _Return my socks_

and my _Large spoon with the silver end._

Thank you.

Many thanks to whoever opened up a package that was addressed to me, and stole $19. worth of cat food. Opening up someone else's mail is a _federal_ offense.

I hope your cat chokes on the food.

:)

To whomever put up the note wishing death upon someone's cat over $20 dollars,

I (ZE) took the note down. I didn't steal your cat's food. I don't have a cat. Did you consider the evil felon who stole your cats food doesn't live here? There have been a number of workers in the building lately and the food sat there for days. Anyway, I found the note irritating and a little weird (wishing cats dead and all) and took it down.

4:10pm 35 SECS.

TO THE OPERATOR OF
THIS CAR

TODAY YOU PARKED IN
FRONT OF A HOUSE OTHER
THAN YOURS. WE REALIZE THAT
THIS IS CONVENIENT FOR YOU
DUE TO THE STREET SIGNS,
THOUGH THE SIGN READS
12 NOON - 2PM SO PLEASE
HAVE SOME CONSIDERATION FOR
OTHERS, AND PARK YOUR CAR
ON YOUR SIDE.!!
WITH MANY THANKS
YOUR NEIGHBORS

© Hallmark Cards, Inc

THINGS TO DO THIS SUMMER:
1. WATCH BASEBALL.
2. ENJOY PROSPECT PARK
3. SWIM IN THE OCEAN

THINGS NOT TO DO
THIS SUMMER:

1. DO NOT LET YOUR
DOG SHIT HERE

2. DO NOT LEAVE YOUR
TRASH/UNWANTED ITEMS HERE

3. DO NOT TAG ON MY
DOOR - please :)

To: Residents of 1756
From: VERMIN INC.
Subject: A Quick Thank You

 The rats, mice, silverfish and ants of Vermin Inc., Toronto Chapter, extend our heart felt thanks to the humans who live at 1756, for their continued excellance in leaving the kitchen a mess. Due to your single-minded devotion to not picking up after yourselves, we vermin have been able to produce more "in-house" spawn than ever before! With your continued assistance, we are optimistic that our recent collabarations with Stray Cats LTD. and Big God-Damned Racoons + Co. will come to fruition in your house as early as October.

 As a small token of our appreciation, we have crawled all over your silverware, as well as pooped on your plates.

 Everyone here at Vermin Inc is eternally grateful for your support.

 DEATH TO CLEANLINESS! HUZZAH!!

 —Vermin Inc

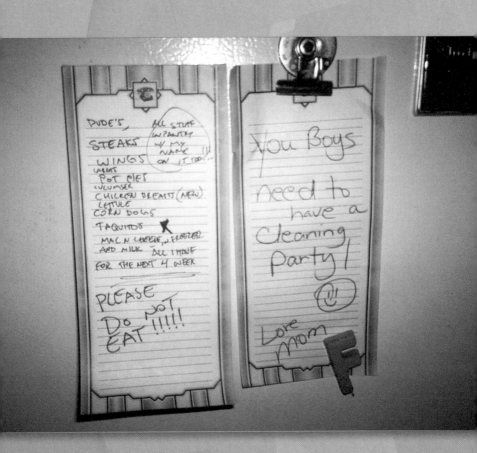

Y'ALL:

This is the 3RD TIME Michael Jackson, Amy Grant, and the cast of Disney have invaded my apartment against my will. I tried knocking + was unheard or ignored. I don't want to have to at you out, but if it doesn't stop ASAP I'm calling the police.

NOTICE!

This refrigerator contains PRIVATE PROPERTY.

Ga. Code 16-8-2.
A person commits the offense of theft by taking when he unlawfully takes or, being in lawful possession thereof, unlawfully appropriates any property of another with the intention of depriving him of the property, regardless of the manner in which the property is taken or appropriated

Hallmark House

JUNE 09, 2004

NOTICE

IF THIS NOTICE DOES NOT APPLY TO YOU, PLEASE DISREGARD IT. NOT MANY, BUT A FEW RESIDENTS FEEL AS THOUGH THE STAIRWELL IS A PLACE FOR THEM TO CONGREGATE, SIT ON THE STEPS AND SMOKE, THROW THEIR ASHES AND CIGARETTE BUTTS ON THE FLOOR, TALK ON THEIR CELL PHONES, SPIT, THROW THEIR GARBAGE ON THE FLOOR, ETC.

PLEASE BE INFORMED, THE STAIRWELL IS NOT FOR THE ABOVE PURPOSE. SEVERAL RESIDENTS, WHO CHOOSE NOT TO LIVE AS A SLOB, ARE COMPLAINING, AND RIGHTFULLY SO. THIS IS NOT ALLOWED!!!

ALSO BE INFORMED, HOMELAND SECURITY WILL BE INFORMED OF THE DAMAGE DONE TO THE 2ND FLOOR HALLWAY TABLE, AND ASKED TO COME OUT TO VIEW THE TABLE IN ORDER TO DETERMINE THE MEANING OF THE DEEPLY CARVED WRITINGS.

THANK YOU FOR YOUR ANTICIPATED COOPERATION.

MANAGEMENT

DEAREST NEIGHBORS:

As you are well aware, we are very nice people. On the other hand, we are not stupid. It is clear that on two occasions (including present) you have taken movies from NETFLIX which we have ordered, then at your convenience placed them back as if they have just arrived. I understand that you also receive NETFLIX but the excuse that you didn't know what movies you ordered will not fly here! Please act maturly and responsibly (not childlike) and carefully read the name on the mailing address before taking all NETFLIX packages into your house. Which by the way is breaking postal law, which is a federal offense!

Thanks,
YOUR NEIGHBORS
from ABOVE

Please pick up after yourself..............

Mother doesn't wor[k]

And even if she does you [should] clean up after yoursel[f]

Hang up coats, cl[ean?] labcoats.

Put dirty scrubs [?] in hamper.

. **Your**
here! re des

ll have to

es and

linens

when your
weave falls
pick it up
! ! ! !
. . . .

Dear Shower-Taker(s):

Your hair is pretty when it's on your head,

But once it's off it's considered dead.

So please <u>don't</u> paste it to the shower wall,

Because you must share this shower with

the <u>entire hall.</u>

Thanks.

IF YOU ARE ONLY HERE FOR

ONE DAY; I WOULD APPRECIATE

IT IF YOU **KEEP YOUR HANDS**

OUT OF MY DESK AND ALSO **DO**

NOT TOUCH ANYTHING ON MY

DESK. I AM SURE THAT THERE

IS **NOTHING** ON MY DESK OR IN

MY DESK THAT BELONGS TO

YOU. **SO DO ME THE FAVOR** AND

STAY OUT OF MY WORK AREA.

I LEAVE EVERYTHING THAT YOU
NEED FOR THE DAY ON MY
DESK!!!!!!!!!!!!

THANK YOU VERY MUCH!!!!

DON'T

BLOCK

FRIDGE

DOOR

WITH

TRASH

CAN

Don't
Waste
Post-its

JUST A FRIENDLY NOTE:

KINDLY SHUT THE DOOR WHEN YOU'RE MAKING OUT. NOBODY WANTS TO SEE THAT SHIT WHILE INNOCENTLY WALKING TO THE BATHROOM. NOR DO THEY WANT TO SEE IT IN THE DOORWAY, OR THE HALLWAY, OR THE ELEVATOR...

AND YOU SHOULD SHOW YOUR ROOMMATE SOME RESPECT, I'M SURE SHE DOESN'T LIKE THAT EITHER. IT'S HER ROOM, TOO.

THANKS!

Grow UP
D-Bag "

Hey kids,

I am tired of repeatedly cleaning dog shit off of my $2000 curtains and a $10,000 family heirloom rug. The two of you would have to live here a long time to make that a winning financial proposition.

I know you didn't ask for puppies, but asking you to close a door is asking nothing. You can remember to close a door when you want to watch TV or sleep quietly, but not when I want something.

I don't complain about excessive cable TV bills that I didn't order and that from which I don't benefit.

I don't complain about all of the trash that I pick-up daily from floors, cabinets, and tabletops.

I don't complain when I load and unload the dishwasher of dishes I didn't use.

I don't complain when the heat or AC is running full-blast and two doors to the house are wide-open. (Nor about the $800+ I pay every month in utilities.)

I don't complain when I come home to nobody here and find all the doors unlocked. Or when I wake-up and the front door is not just unlocked, but wide open.

I don't complain about picking-up dirty dishes. Or cleaning-up messes in the kitchen.

I don't complain about picking cigarette butts up from the yard left there by guests I can only assume are white trash.

I don't complain about picking-up the house just a little so that I don't feel like a complete ass when the maids come that I hired to clean-up after you.

I don't complain when the groceries and liquor I purchase are consumed (and not replenished) by others before I have a chance to enjoy them myself.

I don't complain when you sleep with girls in my bed because your room is too messy.

I don't complain when you pee on the floor like the puppies.

I don't complain when rent is paid three weeks late and then in some arbitrary amount.

I don't complain when I carry out the trash and recycleables when I didn't create them.

I don't complain about any of the other things that bug me a little bit.

And these two, I know, are just personal preferences, but I was taught to close cabinet doors and turn off lights when I'm done with them. I don't complain because you learned different customs. I don't complain. I don't even ask you to consider doing things differently.

So when I do ask that doors be closed to keep dogs from defecating in the living room, chewing on rugs, rubberbands, plastic newspaper wrappers, powercords, and remotes, or escaping through holes under the fence, I don't think I'm asking too much.

Please do *just this one thing* for me. Or please move out as soon as possible.

M—

I don't give a shit that you like Jason. I'm going to starbucks with him on Wednesday. He asked me out and I'm going. I'm really pissed at you about ditching me last saturday. You didn't call. You think your so fucking pretty but your not. at Emily's birthday party you didn't want to play spin the bottle because you didn't want your 1st kiss to be meaningless. No fucking wonder you haven't been kissed. I made out with kevin at the movies last year. Amanda saw. Ask her. Die, Bastard.

♡ B

OH YAH, FOR THE RECORD, I'VE TAKEN PICTURES

HAVE A NICE MOVE! :)

If you come into my room one more time or touch my shit. I WILL

call the landlord |tennant board on you!

thanks

BTW, you have no case, and they don't cover roommate tenancy. feel free to check it out!

Why don't you smoke some more drugs
Obviously they're making you STUPID
I didn't touch your "shit" I took my ART.
my candle sconce, my swag lamp and my mirror
I would hate to see them get intentionally damaged

During your move out! :)

P.S. if anything of mine gets damaged or stolen during your move, I will call the police

Mary

please get your shit together. By shit I mean, fill up the water & actually put it back in the fridge when you are done, empty the dishwasher every now & then & quit leaving food (ie noodles) out & on the counter/table. 4 of us live here & messes & such are OFTEN because of you, & that's not fair. I could go on & on but you should get the point. This isn't meant to be mean, everyone is just tired of cleaning up after you. Thanks, have a good night, Nicole

SORRY!

Mailroom closed for a couple Hours! complaining wont do anything. You're all really Bougie and spoiled...BTW :)

Cuz Remember

At least you're not in Iraq, Darfur, Congo, or China

So just be calm/happy/grateful ummmkay?

Like Seriously!

4/20 is only 4 days away?

You Kids are SO LUCKY

In Singapore they'd arrest Everyone

So just Relax

and go play Some ZELDA

TO the FIEND THAT TOOK
MY DEER PARK Water which
was frozen Solid out of the FREEZER
in THE DOOR TOP SHELF!!!!
On 5/30. It was tap. I hope you
enjoyed it. Next time it might have
Something fatal In it. Jerk.
DONT TAKE what's NOT YOURS.

Channa, I swear on all that is good and holy that if you try and clean anything else that you personally did not make messy I will kill you.

sorry Elliot :)

Becca,

NOW look who is the cleaning Whore! I swear that if _YOU_ clean one More thing in this apartment I will personally come after you.

murder wanton (and I know how to use it!)

Seriosly though the apartment looks great!! Its cleaner then it has been since we moved in. Thanks alot!!! But next time let me help

(or I touch anything else I will vacum and wipe else when I get back)

Thanks
your grateful, guilt ridden roomate,

TO WHOMEVER
IT MAY CONCERN-
FLUSH THE
FUCKING
TOILET.
YOU ARE IN COLLEGE
NO MAN WILL EVER
MARRY YOU W/
THESE HABITS.

Dearest roomate:

Prophylactics are indeed not to
be flushed. (source: google)
Please cease this practice.

To You:

I notice you're using my toilet. WONDERFUL!

But sometimes what you do here is too much. Please Know that the PLUNGER is for Public Use.

And no baby wipes in the toilet. Thanks, the Management

144

PLEASE leave the
Vent open a little –
I know it gets cold,
but it helps to
dissipate the
"fragrances" that
accumulate in here
and have no where
to go.

Thank you.

When you use
the Bathroom
Pleas Spray
I can Smell
it in My
Sleep

To cut down on the odor & the self-conscious feeling of having to have a bowel movement in a public restroom... _Flush As You Use._

Because, really – isn't it better to overtly waste the Earth's already-dwindling natural resources in order to save yourself 45 seconds of embarrassment & breathing through your mouth? It's okay. We'll just tell our future generations that they'll have to "deal" because a simple poo was just too much for us to handle as adults.

You knock the phone ~~down~~ again while I'm talking to someone without picking it back up And apologizing, I'm gonna fucking deck you. The TV, VCR, And movies Are mine in the living room. They Are to ~~me~~ be used by me only. You mess with any of ~~these~~ items Again, I'll mess with you.

I will play my music loud when no one is here. If you or Bill show up I'll turn it off or put on my headphones out of respect. I'd expect the same on your part. If you can't, I will make your life a living hell. One simple rule, you bug ~~me~~ or fuck with me And you'll get the horns.

I'm not the easiest person to live with but I do have a heart. Leave me be.

C▓▓▓▓

I'm sorry for all the mischief I've caused ~~to~~ towards you these past few weeks. I think we should sit down together and have a talk so hopefully things can be healthy between us again. I'll be home around 4 o'clock today. I hope we can air things out between us around that time or later this evening. Actually 5 o'clock would be better for me because I have a friend coming over at 4 o'clock whom I haven't seen in months.

B▓▓▓▓

THIS IS A
PASSIVE AGGRESSIVE
SIGN:

DISHES!

Hey Assholes
I wont do or make
Any dishes till next
Friday

Love C▮▮▮▮▮▮

FUCK Y'all

P.S.

No cleaning house
either. . .

In regard to me having to do the dishes, I'm sorry but no I won't do them! It is not my turn! If the tag is not moved along then it should not be the persons name

who it is not moved to who should be punished, it should be the person who did not move the tag along! I don't believe that in the two years that we have been living here I have ever been the giraffe!

If you try to use the excuse that you went away for the weekend then you should have done them <u>before</u> you left, and besides I was not eating at home either! In fact you may have noticed that I have not been home for lunch or dinner all week! And this trend will no doubt continue into the next 2~3 weeks.

Kim

The carpet is fine. :)
You are a drama queen,
C██████ It does take
whit & debate skills to
fight on shakey ground
though.

For what it's worth; I
love parts of you but not
the entire you. I wish you
had more confidence so I
could have known all of you.

NOTE:

Because of the discomfort associated with L████, we (the residents of 305) have agreed that the best course of action is to not allow L████ back into the apartment. This is non-negotiable.

Her personal effects may be retreived by an approved person (A████). .

If the aforementioned is violated, law enforcement will be called to mediate the situation.

Best wishes

MY DISCLAIMER

THIS HOUSE SMELLS LIKE SHIT. I ATE MY DINNER IN SHIT. TONIGHT. THE CATS MUST GO OR BE IN THE BASEMENT PERMANENTLY — OR, SAD TO SAY, I HAVE TO GO, BECAUSE I CAN'T STAND THIS SHIT ANY MORE.

SERIOUSLY,
—L.W.

986
7139
857-2485

P.S. SHIT SHIT SHIT SHIT

Dear A— —

Fuck you. Get your shit
out of here. I don't know who
you think is going on but we've
already told you you had to leave
and nothing's happened. Ma—!
you thin—

noth—
you—
can sho—
hon—

CO-CONSPIRATORS

T hank you to Christian Abegglen, David Ain, Alex, Amy, Ann, Susan Bailey, Jason Baker, Stephanie Barnard, Oscar Bartos, Nikki Bazar, Nathan Bell, Simon Blackmore, Kristina Borgstrom, Amy Branley, Chris Brewer, Emma Brooks, G. Brown, Jenna Brown, Patrick Brown, Richard Buckley, Scooter Burch, Kristine Burdick, Megan Burghoff, Laura Burns, H.C., Mitchell Campbell, Liz Caradonna, Carlina, Cassandra, Patrick Casteel, Cristina Chance, Alexandra Clark, David Cleary, Christa Connelly, Greg and Tania Cooper, Sarah Coulter, Deb, Ludovic Delavière, Ben Diaz, Lauren Dietrich, Jessica Distad, Scott Dunkin, Katie Durham, John W. Eddy, Lloyd Evetts, Sam Farquharso, Courtney

Flynn, Robert Fones, Kate Freeman, Whitney G., Gina, Summer Gotschall, Sarah Green, Anthony Grosso, Rene Hall, Hannah, Ann H., Lauren Heller, Chrissy Hennessey, Nikki Hill, Alison Honey, Ro Hurley, Jennifer Jacobi, Michele James, Jane, Arthur K., Kelly, Kim, K.M.K., Chris Kisela, Chris Kokosenski, Justin Kuhn, Adam Laiacono, Joshua Lane, G. Lang, Derek Lancioni, Jennifer Lee, Rebecca Levitan, Luke List, Hayley Loblein, Luther Lowe, Mary Lucas, Sarah Marriage, Luke Martin, Stacey Martin, Marylynn, Megan McCormick, Scott McIntosh, Caitlin McElfatrick, Julie McLaughlin, Jenny Mercer, Peter Milden, Beth Milton, Ashley Moran, Dave Morgan,Tony Myers, Natalia, Nate, Amanda Nelson, Ashley Nguyen, Nikki, Elyse Novak, Amber Nunn, Steven O'Donnell, Anne Paterson, Patrick, PES, T.P., Kelly Pennington, Peter, Oliver Pilsworth, Jamie Radford, Emily Rainey, Nick Rakovec, Dan Renzi, Laurie Robinson, Bianca Roland, Calum Graeme Ross, Laurie Ruettimann, Lindsey Rundell, Azita Saed, Nathan Samora, Heidi Schallberg, Channa Schlagman, Eli Schwanz, Chris Shively, William Shu, Cullen Simon, Liza Sisson, Roni Sivan, Megan Smell, Emily Smith, Sarah E. Smith, Jen Soldan, Mathew Spolin, Andrew Steak, Andrew Stevens, Jessica Straw, Tanya, Tina, Team Awesome, Ashley Tendick, Chris Tory, Traci, Amber Tsuchida, Betsy Uhler, Chad Vanderlinden, Dean Walcott, Traci Waller, Katherine Watson, Ron West, Kyla Will, Meridith Wolnick, Eryk Woods, Chris Young, Charlie Zerny, Meg Zurell, and the many other anonymous contributors who wrote or submitted notes.

f you didn't enjoy this book, please blame Kate Lee and Anne Cole, as it was all their idea. Or blame my boss Nick Leiber, who graciously looked the other way, or Eric Rachlin and Kate Zimmerman, who did all the work. And while you're at it, you might as well blame Davy Rothbart and Frank Warren, who did it first.

I'd like to thank all of these extraordinary people, and all of the others who egged me on. In particular, thanks to Kim Tranell, Josh Eells, Katy McColl, Adam Harvey, Jessi Hempel, Meredith Bodgas, Brooke Glassberg, PJ Bryan, Emily Hendricks, Kristen Hawley, Robin Monheit, Jashar Awan, Alina Dizik, Jane Porter, Alison Damast, Ted Joyner, Chris Gregory, Rebecca Wiener, Zach Frechette, Francine Daveta, Gadi Harel and Dave Nadelberg—mostly because I appreciate their friendship and advice, but also because I want to increase my odds of being thanked in the forthcoming works of creative genius that I know they will each produce. Thanks also to Jessica Purmort and Jessica Slotnick, for keeping me sane, and to the Troublemakers, for keeping me on my toes. (For them, I add: Thank you, Terry!)

Lastly, thanks to my Grandma Cookie and Papa Mike, for providing me with so much good material. I know this is not a wedding announcement, a graduate degree, or the Great American Novel, but I hope it'll do for now. (If not, I'm enclosing the receipt.)